Suspension

Suspension

Paige Riehl

Terrapin Books

Terrapin Books
4 Midvale Avenue
West Caldwell, NJ 07006

www.terrapinbooks.com

ISBN: 978-1-947896-03-1
LCCN: 2018947642

First Edition

Cover art: Meranda Turbak, *Dis-integrate*, acrylic on canvas

for Aidan and KaYoon

Contents

|

International Adoption Story: It Didn't Begin

with her crowning, the sweating
purple-blue burst through portal,
the head of black hair,
the arm reaching outward.

It didn't begin with despair
(or did it?). "Sign here":
three shaking pairs of hands
in two countries, icebergs between them.

Exacting is hard. The compass slips.
The pencil tip breaks. Perhaps it began
further back—the loving in dark beds
salt-saturated with hope.

No. Before that must have been
glimpses and glances,
hearts carried in pockets
and rubbed raw.

Our beginning is not. Not even
the winter day our baby's
unborn heart just stopped. Walk back
through the brambles of family,

climb through my own blood tree
and the sewn-on branch, the non-blood
(me), adopted (too) but that's not
when. (Not really.)

Whose beginning? Hers? Ours?
We are all wound tight,
loved and replayed replayed
then stuck, forced, and unfurled—

and I am standing here
at this dinner party with the taste
of dirt in my mouth. Everyone
waits for the answer.

Restraint

The guide warns us not to touch
the fragile coral, urges restraint. That first leap
into the salt, the clear sea, the flash

of fear for what swims beneath.
My flippered feet are clumsy,
my breathing stertorous. Beside me

lovers hold hands and float,
their bodies like starfish spread
on the water's surface. Beneath is silence

and gentle movement—stoplight
parrot fish, blue tang, and stingray.
I float with the current, short-sighted

in the blue kaleidoscope.
Can anyone help but hear the thumping
heartbeat when, head finally lifted

to summer air, the sea suddenly so vast,
the white boat and other snorkelers
are just glittering specks windward?

The sea urchins have gathered below
upon the coral—their spikes inches
from my belly. Float carefully in this liminal space.

This must be what it's like, the moment right before
what could, what might be, before the shrill
whistle and an arm waving us all in.

Adoption: Becoming the Verbs

In Seoul I broke a fish with my hands
after the waiter demonstrated, his thumbs

cracking off the head. The fish was dry and whole.
My teeth crunched tiny bones. The waiter smiled,

so I smiled too. Today, daughter, you watch
my mouth, practice words that start with "l"—

louder, listen, love. Your language is beautiful,
a frost etching on the window. I am a lazy failure.

Annyeong haseo. I am nailing shut your future.
Mian-heyo. The moon is blindfolded,

backlighting our book reading. It is difficult
to write what I know you have lost, are losing,

what I hope you have gained, will gain.
One day I will explain that your father and I

never lived in a house built of certainty.
We wandered as if lost, signing papers

handed to us at every corner, writing
checks when asked. Some people hissed.

Others applauded. Neither felt right.
We considered skin colors. *Love is love,*

is it not? Some said maybe not. Worry blossomed
like a crocus at the base of our skulls.

So many adults in two countries chose for you, handed you
like a delicate sculpture from one pair of hands

to another then another and then into mine.
We have already crossed a deep ocean. Now

your petite fingers point at the letters you love—
quick learner. Close the book and we become the verbs:

holding, loving. Your small body a warm question mark.
My mommy. My mommy. You touch my face,

say it again, as if to remind yourself,
as if to remind me. I smile,

so you smile too. I think of words
to describe you: *lovely, light, my love.*

It's the Happiest Place on Earth

so we board the bus to magic kingdoms,
to smaller worlds. We eat ice cream shaped like Mickey's head,
carry lidded mugs for our endless American thirst.

Near the man-made lake,
the calm ducks at the Disney World resort
are almost tame, waddle close to our son's
small hands. He identifies the colorful boys,
the demure girls, the couples in love. Overhead, a bald eagle.

 Here is the moment—the silent swirling of nature—
 the rapid descent, the talons grasping,
 the eagle holding
 that iridescent green head beneath clear waters.

Oh no, our son says, the drowning so near
and heavy on his young shoulders.

We wrap our arms around him.
My husband speaks of the circle of life,
and our son, allowing himself some consolation,
states in his quiet voice,
 It's still sad. And what about
 his family?

Things That Cannot Die

A spoon in a cup of tea.
Letters in yellow envelopes,
the way a hand pushed lines
into the soft paper.
Morning laughter.
A white shirt draped
over her chair.
An open window. The air.
Call of one blackbird.
Silence of another.
November. Summer.
My love for you, I say.
*My love for you infinity
times a million*, my son says.
Sounds of piano notes
as they rest in treetops.
The road from here to there.
Grief, that floating, lost swan.

The Dreaming Woman

You are not an injured angel, side bleeding.
Not a muscled demon, finger curled. Just a man
who had the beautiful hands of Jesus.

*

Oh, anti-miracle. Oh, blind hunger.
What freedom is a yesterday unfinished?
In my mind we become two swirling insects.

*

I impale myself on these thoughts.
As if the act of thrusting myself on your memory
would force you from my blood, my cells.

*

Forgetting is spinning the globe backwards.
I pile the memory pieces of you on a plate.
The dishwasher won't close. The water is cold.

*

Fifteen years and I'm translated into an unknown language.
Fifteen years and the water that touched our hips
has circled the globe. It waits for us near Malaga.

*

Do you taste older? A certain shade of gold?
Gold pears, cheese gold with the rind of living?
I hid your picture years ago and now the shoebox is empty.

*

Somewhere a branch brushes your shoulder. Under moonlight?
A tree drops her dampness on your cheek. The morning sun?
You are lost to me. A chair thrown in the ocean.

*

I am a series of intentional accidents.
Each day is a dry pine needle. I am filling myself
with old tickets and olives and outdated calendars.

*

Sometimes I lay with my cheek against hardwood.
There is breathing in the wood; it enters me like a splinter.
I would not misplace you again, would label your neck in black
 felt tip.

Christmas Day Blizzard

Bismarck, 2016

No sun, no moon. The wind carries
a gag, a blindfold. Mother beats

the pale potatoes, her hand tired
and burned. Everything is wrong.

We are unemployed and unpublished.
We joke about escape, somewhere

warm, no somewhere apolitical, no
just somewhere safe, somewhere

without oil. Beer breath. Blank eyes.
Fear stains our white skin.

Behind the sheet rock,
a squirrel curls into a ball.

Mother's boyfriend mentions
that holidays, booze, and blizzards

increase domestic violence.
Outside, a red snow blower chews

and spits. On TV, the meteorologist
wears a sleeveless dress.

At lunch as the storm
unfurls itself, our child chokes,

the meat lodged
like an unknown future

in his soft throat.
God bless the tender

fathers and their fists
pounding to dislodge

the darkness: what could,
what might kill us.

Edie Watches the Tsunami from Her Bed at Life Care Rehabilitation Center in Las Vegas, March 2011

Through the window was the concrete parking lot. Cars
came and went as if the drivers couldn't decide

whether to stay or go. She didn't belong here, wanted
her La-Z-Boy and trailer, wanted her legs to hold her up.

The diaper made her mad. She flipped the television control,
looking for the weather, finding *Nightly News* and the angry wave

sweeping 500 miles per hour across Japan's coast,
swallowing houses, flipping boats over like bars of soap.

Without her glasses, it all looked blurry, as if someone
had wiped a hand across a wet painting, smeared

it all to brown, the color of dirty diapers. She couldn't
see clearly enough to wonder about the people who must

only have had seconds to realize their own forecast,
the ocean rising up as if the world were quickly tilted,

death rushing toward them like a train. She had lived on
this earth so long, 94 winters, 94 summers. She wondered

if it was her time, said she had other plans, but who is
in control, after all? The sun shone brightly and nothing

had changed really, except that maybe this was it, maybe
it was the beginning of the end, maybe right then

something began rolling quietly across the desert.

Apophasis

I.

It's easy to forget the opening of self like ribbon unfurling,
the way the horizon can seem slanted
and the room a bowl of light, the way that word
(we won't talk about it—*love*—) can taste:
a depth in a mouth
both generous and dangerous.

II.

Like some Sunday afternoon, my years emerge—
a car ride through the country then the city then back,
the maple trees, flax fields, rivers: a distance
but so close that memories are puffs of air on my closed eyes
and so it goes, and so I go like everyone
existing in small rooms, waiting.

III.

There is the lifting of self, of awareness,
God-high. Or do we move ever inward?
And outward to the ocean? Or the real gift—
the way the birds come just close enough but not exactly to
your outstretched hand, and simply wait
for you to drop the bread.

II

Perhaps the World Centers Here on the Ferry to Milos

The saltwater, the sky, the same thick dark.
The rushing sound of the ferry,
as if the world's doorway is just
opening, a suction of life slapping
in and out, an indecision.

Somewhere ahead is a lunar landscape,
a glimmering white island. For now,
only dark on all sides, the boat a lonely
slip of candlelight bobbing. Too many people,
too few seats—a man sleeps
shirtless in the hallway. Children
lay on coats spread on the dirty floor.

The lovers wait, hold their heads
in tired hands as the ferry tilts
side to side, time's metronome.
What lurks behind? What if
there is no destination and only dark?

The ferry tires of talk and smoking.
Black ash falls like burned-out snowflakes.
A woman hears a starboard splash.
A man holds his chilled foot between
his palms. Hours pass. Everything is true
and not true at once. A boy points, says,
I see it. The island lights are blinking.

The quiet gathering of things,
the unspoken collective mutiny
is left behind like a forgotten book.
At the dock, the bones stand up
and walk away without feeling dizzy.
They carry no fire or maps,
no awakening.

Considering the Options

I.

Our son says only three kids in his class
have no sibling, says he can't
push himself on the swing.

Yet, pregnancy is a risky stranger
exhaling fear like cigarette smoke.

There's the pregnancy that didn't last,
 didn't stick,
 the lost baby, as if
 we'd set him aside,
 a forgotten package on a train.

II.

Large envelopes arrive by mail.
Our mouths are stuffed with worry:
 dossier, home study, intercountry, interracial.
We clutch pencils, add vertical numbers, realize
 (awkwardly)
that it's like buying
a new car, a down-payment
 on a lake cabin, a depletion
 without guarantee.

III.

Another winter Sunday, and in Minneapolis
a new mother slams her 18-day-old baby
 into a crusty snow-bank,
winds up and throws that soft body
like a pitcher's fastball.

IV.

We are sending ourselves downriver.

Form 9a / detailed life history:
 my underage consumption, an aged infraction.
 (Do I have it: *Questionable character*?)
Form 10b / asks how many children my brother has
Form 11a / a residence history, domestic and foreign
Form 12a /references, referrals, names of those
 who know our bones, our marrow, our minds:
 whether or not we like to ignite things,
 love our mothers,
 like the feel of gun steel.

The papers stack like sheets of glass.

 V.

The news report:
on a flight to the Philippines,
between stalks of sunshine and cloud,
a woman gives birth.
She throws the baby
in the bathroom trash.
Later, she is identified
by her blood-stained seat—
a red-ringed map.

 VI.

Outside, the dirty snow remains.
Spring is an undeveloped photograph.
The cat's incessant yowling
scratches at my brain. I throw her outside
 (a little too hard if I'm being truthful)
and she lands and lifts her nose
as if to say, *Well . . .*

Perhaps Form 6a should read,
 Describe the last time you lost
 your patience with an animal or human.
Instead, Form 6a makes sure
 I'm not too fat.

IV.

We are sending ourselves downriver.

Form 9a / detailed life history:
 my underage consumption, an aged infraction.
 (Do I have it: *Questionable character*?)
Form 10b / asks how many children my brother has
Form 11a / a residence history, domestic and foreign
Form 12a /references, referrals, names of those
 who know our bones, our marrow, our minds:
 whether or not we like to ignite things,
 love our mothers,
 like the feel of gun steel.

The papers stack like sheets of glass.

 V.

The news report:
on a flight to the Philippines,
between stalks of sunshine and cloud,
a woman gives birth.
She throws the baby
in the bathroom trash.
Later, she is identified
by her blood-stained seat—
a red-ringed map.

 VI.

Outside, the dirty snow remains.
Spring is an undeveloped photograph.
The cat's incessant yowling
scratches at my brain. I throw her outside
 (a little too hard if I'm being truthful)
and she lands and lifts her nose
as if to say, *Well . . .*

Perhaps Form 6a should read,
> *Describe the last time you lost*
> *your patience with an animal or human.*
Instead, Form 6a makes sure
> I'm not too fat.

Don't Say You Haven't Wondered

about the alternate life, the one
you didn't choose. Cobblestoned and sunlit,
there is a blue lake where mallards

pump their green heads and whistle,
true to each other year after year. I travel there
sometimes after I've planned, cooked,

and served the meals, and everyone leaves
the table. The sticky plates are still mine.
The children's toys are sharp underfoot.

Two glasses of Malbec clarify the alternate setting:
the clean house where I am reading poetry.
Footsteps at the door bristle warmth through my bones.

In the distance, a train's horn. All these years
and I haven't let go. I still smell the cologne,
remember the wanting, how it filled me,

the way a hard, clean rain overflows a pail.
I am embarrassed, a little, by this truth,
by the beaten path to this place in my mind.

I remind myself that the music box ballerina
twirls above a set of pins and a revolving cylinder,
a slave to the hand that twists the crank.

In the Teatre-Museu Dali

Figueres, Spain

Three friends, in various states of marriage,
 walk the inner sanctum, circled

by golden figures. Everywhere the breasts
 of Dali's wife. A man leads another
 with Down Syndrome

down a spiraling staircase. We silently follow.

We search for the melted clocks, find them finally
 in tapestry high above a perfectly-made bed

guarded by a golden skeleton. We three whisper
 of our own unmade beds.

 The loving
 of a person might be what
 saves us from the endless desperation
 of living.

Instant Message to Germany

A quick congratulations, like a shout
from a passing car, a package dropped
from a helicopter. It's laced with loss,
such delicate, crafted work.
Bobbins my bones. Woven memory.
Inexpensive tools. Once we were a pair,
passing across one another, twisting
the threads of ourselves on soft pillows.
Your daughter is beautiful, I write.

Adoption Update: Weight for Height Negative Z-Score (Girl Chart—Two Years Old)

You=negative 2 z-score:
the pink graphed line
 a dying downward swoop.

Wasting: Can you
fit into a coat pocket?

Here the lake pounds questions
into the sand,
receding
 and asking again.

Your father and I run between field
and lake, scream.

Insects enter our throats.

Stunting: Do the tiny doors
of yourself
remain unopened?

Undernourished: Are you a baby bird,
 mouth waiting? Are you
ill—stomach twisted,
 insides scribbled?

Forgive us
 our impotence.

At night, the cabin pops
and cracks against
the wind's push,
 a sound like a stranger
entering.

We wake together,
shout
 into the dark.

What Happens to the Twelve after They All Take 2 C-E and One Goes Berserk and Is Taken to the Hospital

Two—starving, could eat tablecloths and picture frames, the globe—the country of China is so red it must taste like strawberries. *Eat it*. Couldn't three stop tapping her head against the wall as if her skull were an egg meant to be cracked? Her tap, tap, tapping is irritating four and five arguing like politicians assigned to empty the world of bitterness. Six can't call staring at his splayed fingers *playing* exactly, perhaps realizing with wider eyes the exact thinness of skin. Seven of the colorful hair sees pink and stiff erasers everywhere, both kinds—triangular pencil-top erasers and the flat rectangular ones—simultaneously feels herself filling with orange rinds, knows when they reach her throat she will suffocate. Outside in the dense snowbank, eight, purveyor of white powder, flops in T-shirt, his head aglow like flames in the night, suddenly still, becomes an emblem of yesterday's landscape. Nine plays the guitar as if gentle chords will take him *there*. Ten and eleven call 911 and sneak out the back door, jog for home, heads full of bees and mouths full of pebbles. Twelve's eyelids become visors blocking out the best of the world—the beauty of the smashed lamp, the Skittle colors on the television—and starts picking at her eyelashes, pulling at the tender lids. Pan camera to angle from above: one released, ten in blue paper gowns, overdosed and lined up on white hospital beds like neat matchboxes. Plastic bags of fluid in, fluid out. Thin curtains flimsy borders. What about unlucky thirteen? One dead in the back seat already as thirteen flies through stop signs and intersections? Thirteen screaming for help, the first to know it's too late, before the mother or father or girlfriend or child of one. Thirteen, not last but the only one to say *no thanks, drug test at work tomorrow*, and now some godless gloating stirs somewhere in the universe and how, explain to him how, can he ever push through the guilt encircling his head like a plastic bag?

An Illusion of Fullness

You matter. You matter, I should say,
should try to fill the zone inside him
with bright certainty as he strokes
our daughter's hair and stares
through frosted windows.

The sideways snow-swirl binds us
to everything dead. The ice film
glosses the sidewalk with risk.

> Years ago, near my hometown,
> teenagers drove across
> the frozen lake. Thin ice
> must barely be audible when it gives.

Between our separate rooms, the air.
Under our eyes, the dark moon's delicate skin.

A job does not make a man, I should say,
should wrap my arms around his neck.
Instead, too close to the stovetop, the steam
surrounds my head, so thick

I fear we both will drown.

Near Chang Mai, Thailand

There comes a point when we know
we can't turn back. Single-file,
sweat-drenched in the 106-degree heat,
nine of us keep our eyes on the dirt path,

on the worn tennis shoes of the stranger
before us. Five miles uphill,
the dense jungle, then a clearing
and the sun like a hammer. Lungs heave

humidity. A young woman pukes.
Narrow, slick path. The steep ravine.
The tree bark and plants I grab
for safety crumble dirt. I know

I should think about journeys
and their unpredictable joys. Yet,
danger is underfoot. Fear of what might be.
Obvious metaphor. Forgive me.

At home, we create our daughter's history
and worry her future. Worry her homeland loss.
Worry mother father language culture loss:
Tangled filament woven through brain.

But our love matters too. Yes? Velvet love.
Yes. Our arms blankets of holding. Kisses.
She is joy: sweet soprano, fascinated
with an ant in her open palm.

Here on this hike, I wish I could say
I sweat out the worry. Muscles like wire,
throats parched, we finally reach
the mountaintop village.

Beneath the waterfall, a child
swims naked, smiles at me.
Cold water jolts tight thighs.
My children are 8,000 miles away.

Wait

Had we known its connotations, the way a word
can rot like fruit, the outer layers growing
vulnerable and soft. The *w* weakens, falls
as if from a sinking boat, the *a*—so outwardly tough
in its singularity—hollows like soft butter
under a finger. What remains is what we are waiting for: *it*.
But the *t* dives with arms spread wide,
a cross crashing on the shore.

Suspension

Here is what lies between us:
6,221 miles across the earth,
across states like jellied candies
on the map, the Pacific's aquarium
is the pale blue of an old woman's eye,
the curved arm of Japan, the brown leg
of South Korea—where you are—my love, my daughter,
measured in 10,012 kilometers. I cannot translate.

 Here are interstates crossing
 unplanted cornfields, the cities with their green
 7-Elevens and BPs, the heady gasoline,
 the rows of sticky doughnuts gleaming
 a sugar varnish, the check-out girls
 with their ponytails and tattoos. And
 if I could drive beyond the flatness familiar
 as my hands, beyond mountains, beyond
 barrel cactus and prickly pear, beyond all those stretching
 shadows, to the California coast where the water and sand
 hold such promise in the sunlight and move
 across boundaries easy as breathing,
 I would look west. What then?

Here is what lies between us:
365 days (or more), bland
and humorless as an old uncle.
Another rainy April. Roads crack;
potholes fill with water while blackbirds
dip their heads to drink. I put sweaters
in plastic boxes, snap them shut,

buy you dresses in sunny pinks, yellows, greens
that split the gray air. I am ready for spring.
Ready for forward.

> In the backyard,
> the water fills the tarp-covered trampoline,
> freezes to ice in April, strains the thick springs.
> The shovel's sound is dull,
> my gloves and jeans wet from the effort
> of breaking the ice chunks that refuse to melt
> even when I throw them on the ground,
> even in the warm rain.

Here is what lies between us:
the young dictator to your north—waking
his own growling history—
moving missiles, liking the sound
of his own voice, revving his engines
and armies. Each day the television is
my portal to your city. The beautiful girls
in Seoul sit by the Han River.
City officials hang bulletins now:

> *What to do in case of a mushroom cloud.*
> *What to do if the birds all suddenly fall from the sky.*
> What birds in the cherry blossomed trees?
> I imagine their falling wings like black smoke
> lost in your small irises, imagine
> your foster mother running
> with you against her shoulder,
> your hand clutching the yellow rattle.

Here is what lies between us:
5,402 nautical miles and sharks

and I can't sail. Deep waters.
A ship deck of paperwork
floats somewhere hazy, awaiting approval.
Missile defense weapons slant as if in salute
on the island of Guam.
You are marooned in an apartment near Seoul.

But you do not know I exist,
so I am marooned in a house in Minnesota
in my own dreams
where I feed you banana
and we dance in the kitchen.

Here is what lies between us:
My birthday, 44. Your birthday, 1.
Combined they are an odd number,
so odd that I love you
already—your laughing face,
the way you stare beyond
the camera at someone
who reaches for you
when the camera stops clicking.

I carry my sadness like a backpack.
From my tongue whispered confessions
fall into heavy, strange shapes
over which I trip. I am told my
demeanor has altered. I slouch.
At the grocery store
I smile at a baby. She
looks away.

Here is what lies between us: everything.

Land, sea, desert, miles of unknown.
I cannot see where you are.
Do curtains flutter in the spring breeze?
Are the wood floors warm beneath
your bare feet?
I cannot color the walls of my mind.
What sounds from the radio?
Nothing comprehensible.
Politics are bubbling
over, running toward
your playground.

Here is what really lies between just us,
between our empty arms, our open hearts:
only now, only this waiting.

IV

Dragonfly

You are soul-weigher, tiny
devil's horse, doctor
of snakes. You are strength
of late summer, double-barred
cross of courage and speed,
rendered flightless
with two pebbles
and a string
of child's hair.

Adoption Webinar

The laptop between our plates,
 my husband and I watch the PowerPoint slides,
listen to the faceless voices—our own muted—

on spring's first 70-degree day. The sunlight
 slants shards across the deck, the grill's heat
shimmering a dreamy haze. We chew quietly, are thirsty

wells. There is a small box, as wide as two baby fingers:
 a space to type questions. Program changes curdle
like wishes in the sun. New Korean judges take

extra steps, the flow chart an unclear evolution.
 The biological mother will be found and asked again:
Is she sure she wants to relinquish parental rights?

I envision her: white dress, gleaming hair, hand paused
 above the dotted line. She has not seen her daughter
since birth. Neither of us has kissed the baby's face

as she grew, our daughter's face now framed
 on my kitchen counter, in our minds. This mother
and I are empty flowerpots waiting

through winter. Now, dusk's mouth yawns. Here
 in Minnesota we eat. Feel edible. Across the state
in another town, other waiting parents ask:

Have any of the mothers changed their mind?
The daffodils push against the still frozen earth.

Muscle Memory

I.

Like the roots of trees hugging the earth, all knots
and twisting exposed, my mother's feet have turned outward.

Perhaps it was the shoes—the high heels of secretaries
with their early ambition, their toes pinched in triangular spaces.

Birds with clipped wings in small cages.
Perhaps it was heredity—genes and DNA curling muscle

and bone, the body's molecular foot binding.
She waited too long, until the bone and soft tissue

of bunions expanded over decades, her feet
growing bone like decoupage marbles. She waited

because her own aging mother needed groceries,
errands. Gradually, a lost center of gravity.

Audible: the earth's rotation rings in the distance.
Physical: the inner ear spins, the foot's confusion.

A fluttering. Then there is falling
over the vacuum cleaner and two broken arms.

Sidewalks emerge as hazardous open spaces.

II.

Dear Jesus. The surgeon shaves and hacks a hard V, a piece
of bone pie. Each foot is plated and pinned. Reconstruction

and resurrection. She is booted and wheel-chaired. She is watching
The Young and the Restless from dark corners. Still, the feet

hold muscle memory; the feet ache to defy steel and stitches.
Her own mother dies while my mother is wheelchair-trapped.

After the funeral, the coffined body lifts in a plane like a white arm
rising above the desert. She is buried under Kansas prairie grasses,

where she and my mother ran barefoot as children. Grief and guilt
spin a strange dance. Litter in the wind. My mother waits

behind a door closed against the Las Vegas sunlight.
Overhead, the planes shuttle tourists unaware of dead mothers

near suitcases stuffed with flip-flops and swimsuits.
Even after the doctor says *stand and walk*, my mother is hesitant

to feel the earth. She will pause and listen, the depth
of absence and loss so silent it almost sings. She will pause

before that first step—all her weight
on the desert's flatness, on her own body's twisting.

The Press Secretary

He has eaten too much. His stomach
clenches while his mind juggles words: drop
denotation, manipulate semantics, practice

hasty generalizations. He toggles
between thought and sleight-of-hand.
Outside the café is the sharp smell

of something rotting. He imagines
an unholy kitchen, salting and buttering
words, burning their edges. The words

are fatty and smoke. The press secretary
considers the blue sky, the whiteness
of buildings. He mulls meaning,

dreams a cold fog of semantic
satiation. He chews the world.
He has emptied his plate.

Sunday Biking

Near the river valley, the sound of forgiveness
is a reckoning soft as leaves falling.

Our bike wheels whir on the blacktop
past grandiose and dark houses.

I could continue to manufacture
mental boxes of unhappiness:

could continue a one-click instant delivery.

I pedal the u-curve
of discontent, pant through

this nadir of mid-life,
a laundry basket bottom of existence.

But there to the left is the blazing sumac,
the sharp ravine, the formidable

cold river. To the right a weeping willow,
a window flashing a carmine and honey sunset.

We are all dodge-balling dissatisfaction.

Sloping hill, picking up speed,
I fly past family

who call out to me, the wind's thrum
muffling everything,

the danger a rush I must forgive myself.
I must forgive myself this joy

of spinning away.

Ninety-Fifth Birthday

Like a child, she innocently bites her lower lip,
shrugs her shoulders. *Why not a big party?* She longs
for the past: chocolate cake heavy as the future, presents
with their small surprises. One by one, the people she's known
have vanished like puffs of smoke. The past stacks up
around her. The boxes grow soft, heavy

until she cannot move them, so we gather
to organize and stack. The daughter peers inside
and shakes her head. What is there to do?
We are all complacent. We know what will hit this trailer
in the Nevada desert like an unexpected dust storm,
when we will gather again, open these boxes and scatter

their contents. How will we determine value? Distribute items
like hard candy? This one for cousin? This one for uncle?
Our arms will be heavy: the photos, the ceramics,
the new Tupperware. For now, at the party, she tips
her empty coffee cup, peers into it as if the stained bottom
holds all the answers, then raises her eyes,

a silent request for more.

Dear Scleroderma

You, the ever-present but often misunderstood
scar on my left arm, that shriveled sister.
No one understands your full name: *linear*
meaning elongated, stretched, skin like thin

parchment scribbled brown,
and *morphea*, pink and white patches
like the bite of winter into skin and blood.
No, not "morphia," the drug to deaden pain.

No "Morpheus." (Why not a God of Dreams?
Some ebony bed surrounded by red poppies?
On it I could sleep, some drug
or God to shape my dreams.)

In the spring the stares of strangers:
What happened to your arm?
Winter sweater gone, skin now exposed,
tight like plastic wrap, the fingers thin and curved

like an old woman's or a bird's claw.
What shall I say? *Scleroderma*: disease,
the body's rare war against itself,
the immune system a dictator,

the skin the proletariat landscape.
But that is melodrama, a half-truth.
Still, arm of mine, we are entwined,
tangled branches of the same tree. I will nurse

your brittleness, your wilted browning limb
and when summer comes, I will take you naked
into the sun and the rain and the air.
Yes, we are all flawed and dying, each day

a scar here or there lifted toward the light.

Color Guard Practice

St. Olaf College, Minnesota

The leader points the muzzle at her heart,
demonstrates how to swing the rifle's butt
in a slow arc above their heads,
the warm plastic nestled in the soft place
beneath the collarbone. In short shorts
and tank tops, long hair piled loosely,
the eight teenage girls toss, flick, and flourish.

They worry about missing, the gun
slicing bare midriffs and legs.
Beneath the green maples, they learn
to move fast—step back and side step.
They want applause for their beauty
and synchronicity, unanimous guns
pointed in rhythm at their young bodies.

They do not understand danger.

How can they consider battle
when they call the muzzle a nose?
When their guns have no trigger,
no need for a safety? Each barrel's silver stripe
is a mirror flashing in the sun. Their rifles
are already the color of surrender.

They will learn how lithe bodies age,
will learn how quick hands become
lifelong defense against hurried men.

There are no rewards for a clumsy girl.

Mother Tells the Girls about All Good Things

—after Dorianne Laux

We were always waiting for something: recess, our turn
on the spinning playground wheel, the bus driver to see
the kid shooting spitballs, the cat to birth her kittens
in the hay bales, the stray dog to stop pacing
at the screen door, the walleye to bite, Grandpa to turn
the boat toward shore so we could pee, Dad
to come home after a week on the road. We were tired

of franks and beans, being picked last for kickball, practicing
multiplication flashcards in the corner. We waited for breaks:
summer break, a break in the August heat, Christmas break, the break
in the arm to heal. We waited for school to start, the water
to boil, the clothes to dry on the line, the piano plinkings
to signal the start of *The Young and the Restless*, the curling iron
to heat, *The Wizard of Oz* on TV each spring, scholastic book orders
to arrive, the Russians to drop the bomb. We waited

for first spring dances and yellow crepe paper under which
we imagined first kisses. We didn't wait long for beer
in crushable cans, the ones we learned to stomp
under our tennis shoes, flat as tomorrow. We waited
for the bonfires to lick hot against our cold
beer hands, for the beer to take hold so we could kiss

the one whose face flickered in the orange firelight.
In the morning, we waited in bed for the headache
to subside, waited to get water, thought about licking
the frost off the windows. We waited for sex, waited
because that's what parents and the church and God said
to do, waited because the flames of hell waited
for those who didn't. In the doctor's office

we waited for the doctor to stop stitching our head,
the cop to stop threatening our mom, then the town to stop
gossiping how we must have been drunk
when our car went off the dead end, about how lucky
we were to be alive, waited for the probation officer
to stop calling *just to check*, waited for the Chevy Citation
hand-me-down to haul ass to the big city
where the college waited with open dorms. There we waited

for chemistry class to end, for the party to start. We waited
for Mr. Right in the wrong bars, waited on the barstool
for the handsome but absent face, waited for our tears
to soften the bank teller who canceled the overdrafts,
waited for the economy to improve, for the feta
and the hummus and the Thai we'd never tasted,
for the sound of an accent in our ear, for the truth
of the matter and all other clichés, and then
when we had it we rolled in it licked it loved it opened
ourselves like an envelope and sealed it up inside.

Desire

It came like a hailstorm,
how we were caught
in the updraft,
breath sucked from our
air-hungry lungs, swirling
up and into each other until
we were condensed, layered.
The extreme drop and lift,
the growing weight of us—
how were we to know
the hot and cold of it?
I could have stayed there
forever. But I couldn't stop
the rapid descent,
how everything blurred
against the glowing white
of our fall.

In Avignon

the car is too big, the wheels scraping
against the narrow sidewalks, a sound
like the world's trapdoor opening. The stone
streets, the heavy doors of buildings, the sun
clinging to the air above the rooftops.
We three women hold a ring

of three giant keys, special instructions
for sequence and turning, the keys
like weird crochet needles jabbing
at the door. A woman peers out
of her window, her gray hair and eyes
fluid as if she sees through our commotion

to her past. The wine, the duck in rich sauce,
and the rigid mattresses force us
to move as if underwater.
We travel together into strange spaces.
We walk with empty arms
into the city squares, to the vendors selling
Santas climbing ropes, vin chaud, toys that bounce

by springs and rubber bands. We want
our bodies back, such shameless desire
for everything. Now. We are transparent opals
tucked into pockets. Right here—thousands of miles.
How far we've come. The old popes
are dead in their crypts, yet feet still feel
the uneven stones that line the insistent

streets. *Look*, we think, *just see*
the way the elderly couple sits, each holding
a glass of wine in one hand and with the other
petting the panting dog. We women feel
no fatigue, no sadness, just this December day
in the bright square facing the setting sun,
our old wounds closing at night, like tulips.

Waiting for Grief

The silence of the morning takes
a deep breath and holds it.
Press play. The pause right before
the music begins.
The Christmas lights blink and blink,
then the moment when one
says enough, and all are dark.
The slip of light on the garage floor
just as the door yawns shut.
The unwrapped Christmas present,
receipt still attached.
Inside of me, the kettle of water,
the gas burner on low.
The farm basement
that remembers the brightness
of canned tomatoes, their jars
like summer stuffed in glass. It waits.
The way we notice now so many
black cars driving slowly.
The boats of so many things left unsaid
gather and circle.

V

Hospital Break

Nurses are fast shadows ducking our fear,
wrapped thick as flannel.

The midnight clock. Antibiotic-haunted
dreams: cold hands stabbing soft belly.

Whispered laughter. Could we puppet-rise, shuffle
down corridors, cry together, holding hands

without words. Too much walking pain:
paper bones, cloudy blood.

Deep-celled fear. I am a bag of rags.
Lunch stinks uncollected.

My infected pelvis propagates hurt:
a winding vine twisting to fevered brain.

Moments ago, we were the healthy—
gunning the accelerator, wind whipping,

sipping hot Starbucks, eating sweet peaches,
sleeping sprawled with windows open

like anyone else. Like you.
But then.

Leg cuffs puff and deflate, pushing
blood to heart and back. I am starfished

and bruised on the bed, connected
by all appendages. The window offers only

mottled gray sky—no robin's puffed, red belly
to match my own.

The Desperate

No birds outside the window—
only a brick building exhaling smoke.
The long corridors are quiet tonight
except for a TV's shouting sportscaster
and someone crying. *Some people are just fragile*,
the doctor says. I become cracked porcelain.
3 a.m. and I sleep with the lights on like a child.
I am drifting. Open sea. A drowning tiger.
My bones whimper. My blood thirsts.
I wish someone would touch my hand.

The crier, the TV watcher,
the new delusional across the hall, and I
long for cool silence. Behind our eyes:
sweating organs, pulsating blood masses.
Primitive. *Do you have a low pain tolerance?*
asks a blank-faced nurse. *Expect pain for weeks
or you'll be disappointed*. She is scrubbed clean. Raw.
Oxygen becomes serrated.
For the first time, I understand suicide.

The Lucky Girl Clutches the Bag of Pills

Yes, there is worse suffering: *Code Blue
in pediatrics*. Squeaky shoes sprint the hallway.

A state away my friend's father falls from a camper roof
 and breaks his neck.

A couple of days from now a baby will be born
 not breathing.

How unfair this world.
Why this random misery?

Pills scratch aluminum in my throat. Metallic mouth.
Yet, I will eventually exit this pain cave.

Across the hall, the delusional screams again,
Get away from me! Nurses murmur.

When their shift ends, as they walk through
the damp parking lot, we drop

from their backs like lost shawls.

The Country

is windowless,
a crowded cattle car moving

into a blank landscape.
One by one, our hopes

crumble beneath our feet.
We queue for anti-anxiety,

open our dry mouths,
tongue waiting, become a motley snake

eating its own tail. We cannot
shed our skin—we jostle

to our sharp corners.
Dense marbles of worry gather

in our stiff necks. Nearby,
a mother stitches her son's mouth shut.

Another ties a red tourniquet
over her daughter's ears. Our faces

are made of sand. Our bellies are full
of darkness. It smells like a fire dying.

Someone flicks a lighter,
a miniature flare for help.

The Rabbit Is Unafraid

Our pale bird arms, our slender feet
announce themselves delicately—
those first unadorned spring steps

body parts un-layered,
bellies loose and smooth,
patient like the rabbit

somehow fat after winter,
full of every green only recently
peeped from the black.

He moves with confidence,
the dirt hole under the fence
smooth as an agate

from his furry belly. Spring
understands slowness, the way
the rabbit and I, only feet apart,

squat and sniff the edgeless air.
Soon we will be at war,
this rabbit and I,

battling over the hibiscus
and hostas. For now, truce-like,
we are statues. Only the tiny hairs

inside our ears quiver, listening
for summer's tremors, the rabbit and I
like the earth's ripe stamen.

Meditation on Forgetting an Old Lover

A friend once told me
I should envision your skeleton:
just the bones stacking
white upon one another,
maybe the skinless pink muscle
because it isn't possible
to feel passion
about femurs and scapula,
all collagen and calcium,
such cold science.

How can she know
your smooth bone
is a pure escape
under fingertips?
I have always been a good
climber. I curve fetal
into your ribcage,
find comfort in clutching
the horizontal bars
of your body.

The Space Between States

She stares out the window. All this time,
this space between yesterday's solid rock
and tomorrow's bowl of sadness

floats like dandelion fluff between us.
There is space on the phone line
(some call it static, but it isn't so),

dark synapses between memories,
space between the real or the hallucinated
or the heavenly (no one is sure which).

She sees a little girl in the room, says,
She found me again! Her finger points
to an empty corner. Autumn is over.

Yet, she lingers, and someone enters
her space with a handful of pills.

Like an Apocalypse

Online a story:
in the city of Yongin
an unwed mother
gives birth. She presses
her hands hard into the baby's
small chest, sure hands
as if pressing into clay
or dough. She places
her murdered son
in a plastic bag and then
in a suitcase.
On Facebook
a woman writes,
"a better outcome
than being shipped
overseas."

Post-Adoption, The Naming

I.
Girl of so many names,
written horizontally and vertically,

rearranged
by trembling hands.

Each is a truth,
a blanket to wrap
 or fling into the fire.

II.
We wish no harm—
we as (birth) Mother, (foster) Mother,
(adoptive) Mother.

We separated
 by black oceans and wrinkled calendars.

We weighted
 by our labels, such heavy coats.

We wish
 you the past as a compass,

wish you today
as a curtain
opening,

wish you decades in sprawling cities
in languages,
in moonlight, in oceans.

III.
Three mothers' arms
like flowering pears.
There are so many ways
to view this—
 but who am I to say?

I've heard the fury from others—
 infertile white bitch—

Yet, I come from the place
where it is easiest to be happy.

IV.
In ten years. Twenty.
Perhaps contented afternoons.
Perhaps slammed doors,
the voice like a hammer.

Words. Lightning bolts
in a drought. I will offer you water
from my cupped hands.

In Hospice, Such Small Disturbances

No one can remember her last words. Days ago
they lifted over the neon casinos, refracting

into shards across the brown desert. Like a love song floating
just above someone drowning, the radio plays Christian rock.

My cousin turns the knob, searches for big band reverie, horns
like a divining stick to large, colorful rooms. How can we

find the river of sound and scent and pour it
around her tired body? Enough that she can submerge

in what she loved of this world? The lilacs, the violins, the high heels
for dancing? Just beyond the glass door, my mother

warms herself in the blurry Las Vegas sunlight, answers
another phone call, the faraway voice from some other state

where no one, and everyone, is dying. In the shared room,
the television program replays violent accidents:

a ponytailed cheerleader missing the mat, her head hitting
the floor—a sound like the world cracking. Such fascination

with near death. Rubbing his eyes, my uncle stands and teeters,
as if the floor is fine sand pulling him away from,

or perhaps into, imperfect places. The waiting is strange—
and shameful—a pause before we exist in an altered reality.

The doctor enters and answers with questions.
We stand: tilting toward each other,

unconsciously leaning away from her.

Meeting an Old Lover

In Australia I'm jet lagged, waiting on the hotel bed
and wondering. Thirteen more years sketched

around my eyes, thirteen more pounds circling my waist.
In the lobby, he smiles and hugs me, says my name as if

it were a misplaced memento. And then we laugh: *This is weird*.
On the ferry to Manly Beach, he raises his arm and points,

my tour guide. When we hike a path near the sea and I take off
my jacket, he sees my scarred arm and touches it,

says, *I'm remembering now* as if I am emerging
slowly from an ocean of women. In the sunlight we stare

at the Pacific cold and deep; thirteen years ago it was Scotland
and the rainy Atlantic. Over beers we face each other,

share stories about teaching. His hair is now short and dark,
not long summer's blond. He says he reads the story I published

about us at least once a year, finds the journal whenever
he moves, his claim to fame. He's still unmarried, childless.

His parents finally are divorcing, he says, *a gift*. I think
of my family at home, our backyard of flowers

and feel myself letting go, as if releasing
a breath I didn't even know I'd been holding.

This Is the Hour of Returning

Arms are purple flowers,
veins wilting stems. Exit
this sequestering. Not another
blue hour. Not another yellow needle.

Wheel-chaired out, the air
is bright-clean in my lungs.
Stoplights are jewels. Trees—God,
the trees standing so straight. In the car,

never mind that potholes
become pain landmines.
My belly burns flags:
I am sexless, weightless,

exhaling chemicals, bound
by cellphone beeps—medication notifications.
I walk wounded, a curved C.
Yet, I enter my bright kitchen,

the smooth counter. The solid chairs.
I am here. My son and my daughter
wrap their arms around my waist
again, again, as if

I am not a fevered imprint, as if
I am not a skeleton pencil sketch,
as if I am me and tomorrow
is as certain as the way they run

into the living room, certain
I will be sitting at the table
when they return.

Acknowledgments

I gratefully acknowledge the editors and readers of the following journals where these poems, some in slightly altered versions, first appeared:

Adanna: "Adoption Webinar"
The Adirondack Review: "The Dreaming Woman," "In Avignon," and "In the Teatre-Museu Dali"
Artful Dodge: "Post-Adoption, The Naming"
Big Muddy: A Journal of the Mississippi River Valley: "Christmas Day Blizzard"
Brain, Child: "Suspension"
Cleaver: "Things That Cannot Die"
Crab Orchard Review: "Restraint"
Free State Review: "The Rabbit Is Unafraid"
Great River Review: "Color Guard Practice" and "Don't Say You Haven't Wondered"
Knockout: "Ninety-Fifth Birthday"
Literal Latté: "Edie Watches the Tsunami from her Bed at Life Care Rehabilitation Center in Las Vegas, March 2011"
Literary Bohemian: "Meeting an Old Lover"
Meridian: "Waiting for Grief"
Paper Darts: "What Happens to the Twelve after They All Take 2 C-E and One Goes Berserk and Is Taken to the Hospital"
Peninsula Pulse: "Perhaps the World Centers Here on the Ferry to Milos"
Poetry City, USA: "Dear Scleroderma"
Portland Review: "Instant Message to Germany"
Revolver: "Adoption Update: Weight for Height Negative Z-Score (Girl Chart—Two Years Old)," "Apophasis," and "Wait"
South Dakota Review: "In Hospice, Such Small Disturbances" and "Mother Tells the Girls about All Good Things"

2014 Saint Paul Almanac: "Dragonfly"
Water-Stone Review: "Adoption: Becoming the Verbs" and
 "International Adoption Story: It Didn't Begin"

"Apophasis," was reprinted in *Revolver Reader* in *Medium.*

"Edie Watches the Tsunami from Her Bed at Life Care
Rehabilitation Center in Las Vegas, March 2011," "In Hospice,
Such Small Disturbances," "Mother Tells the Kids About All Good
Things," and "Waiting for Grief" appeared in *Blood Ties*, a poetry
chapbook (Finishing Line Press, 2014).

"Edie Watches the Tsunami from her Bed at Life Care
Rehabilitation Center in Las Vegas, March 2011" won the 2011
Literal Latté Poetry Award.

"Dragonfly" was selected for *Everyday Poems for City Sidewalk,* a
work of art by Marcus Young, City Artist in Residence, as part of
a joint program of Public Art Saint Paul and the City of Saint Paul.
"Dragonfly" is stamped in the sidewalk in various locations
around Saint Paul.

I am grateful to my family, friends, and colleagues for their
support. Thank you to Damien, Aidan, and Evie KaYoon for their
love and for allowing me time and space to write. For the shared
travel experiences that inspired some of these poems, I thank
Missy, Cyndi, Krista, Lyndsey, Cindy, and Julie.

Thank you to the following poets, mentors, teachers, and friends
for their guidance and careful feedback on my poems and book:
Deborah Keenan, Jim Moore, Jude Nutter, Oliver de la Paz,
Gretchen Marquette, MaryAnn Franta Moenck, Kelly Hansen
Maher, Molly Sutton Kiefer, Billy Collins, Naomi Cohn, Barbara
Davis, Alice Duggan, Lia Rivamonte, Carolyn Williams-Noren,
Kathryn Kysar, Scott Wrobel, Caitlin Bailey, Nancy Hanson,

Jim Heynen, Brett Elizabeth Jenkins, Katie Rauk, Jeanne Lutz, Susan Solomon, and Pamela McDonald.

My unending gratitude to Hallie Wiederholt. I have been blessed by your insight and support.

Thanks to the Jerome Foundation and the Loft Literary Center in Minneapolis and all of the Loft's current and former staff, particularly Jarod Santek, for support throughout the Loft Mentor Series. To all of my Loft Mentor Series cohorts, you continue to inspire me.

Thanks also to those who helped me grow as a writer in the early years: Mark Vinz, Al Davis, David Mason, James Autio, Kristen Bleninger-Sundar, Laura Gilles, Eric Gustafson, Lyndsey Howard, Preston Mark Stone, Ryan Trauman, and Kevin Zepper. I am grateful for my teaching colleagues and many other wonderful teachers, writers, and friends for their support.

About the Author

Paige Riehl is author of the poetry chapbook *Blood Ties* (Finishing Line Press, 2014). She has published poems in *Crab Orchard Review, Water-Stone Review, Portland Review, Meridian,* and elsewhere. She won the 2012-2013 Loft Mentor Series in Poetry and the 2011 *Literal Latté* Prize for Poetry. She is a mentor with the Minnesota Prison Writing Workshop and the Poetry Editor for *Midway Journal.* She teaches at Anoka-Ramsey Community College and lives in Saint Paul, Minnesota.

www.paigeriehl.com

CPSIA information can be obtained
at www.ICGtesting.com
Printed in the USA
BVHW07s1304020818
523238BV00002B/142/P